This Book Belongs To:

SweetTree Books/Colorist Café

Copyright © 2019 SweetTree Books/Colorist Café

All Rights Reserved.

This book or any portion thereof may not be reproduced, distributed, transmitted or used in any manner whatsoever, including photocopying or other electronic or mechanical methods without express written permission of the publisher.

SweetTree Books/Colorist Cafe
1230 Millers Chapel Rd.
Greeneville, TN 37745

Visit author/publisher's website: ColoristCafe.com

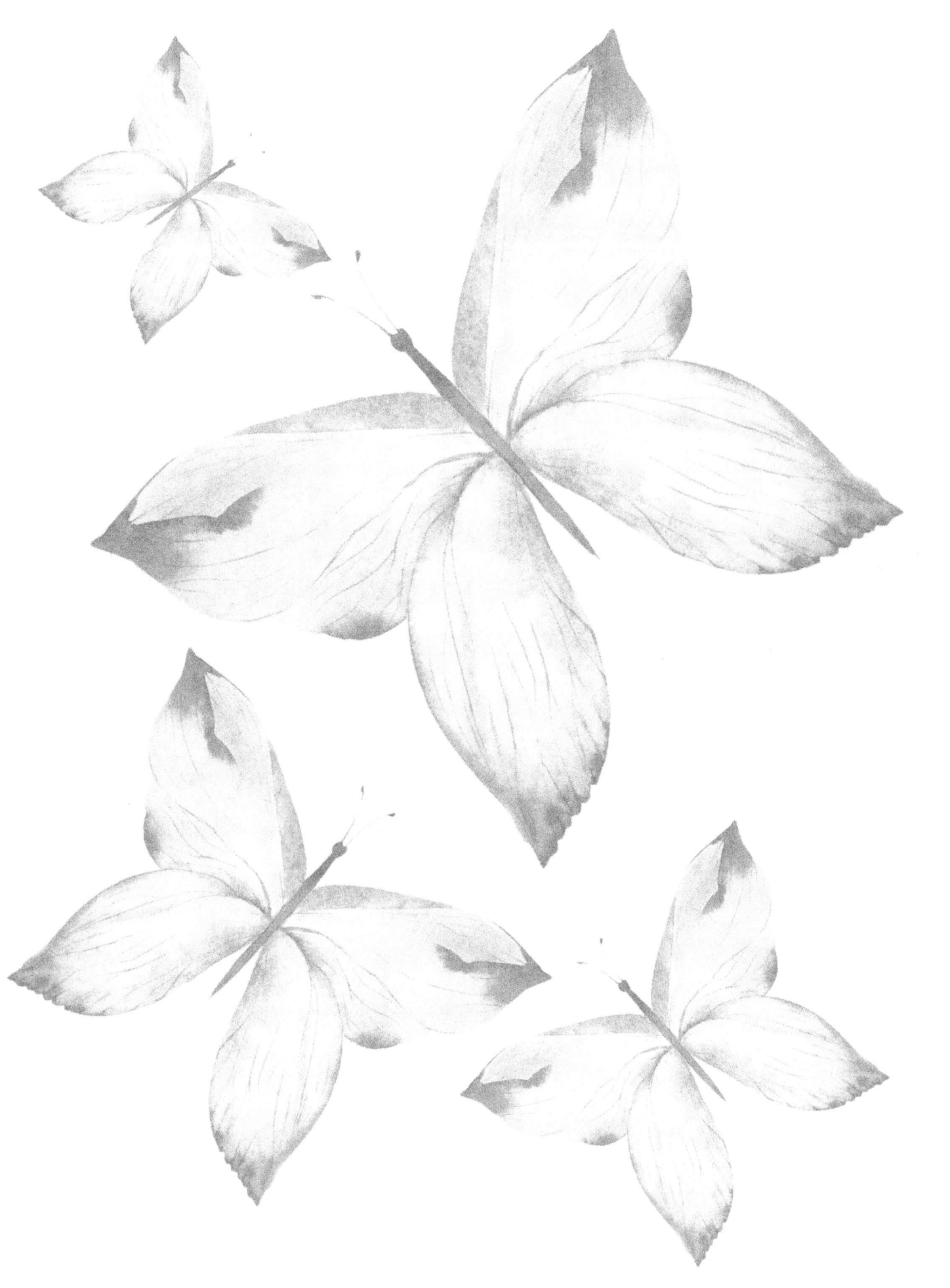

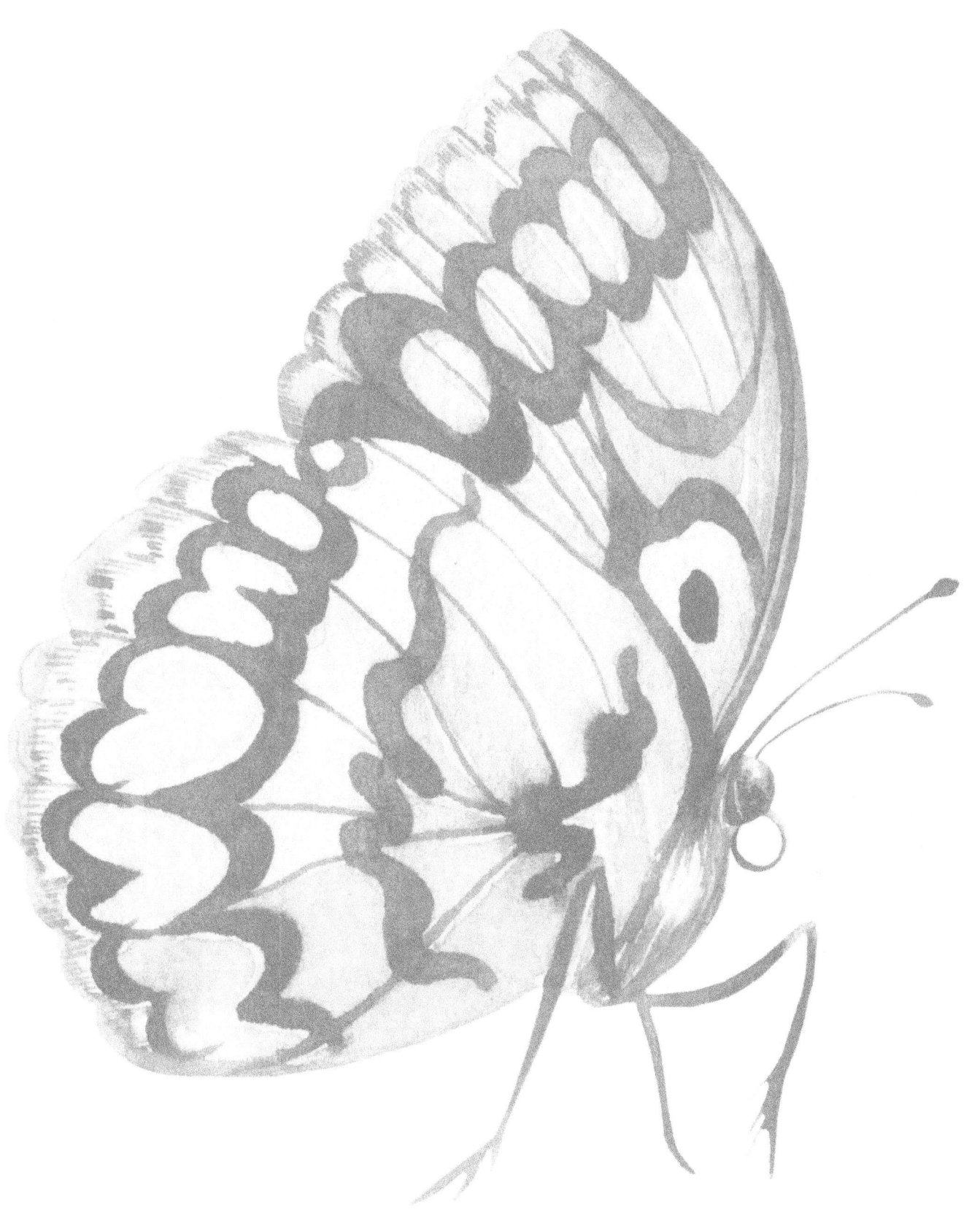

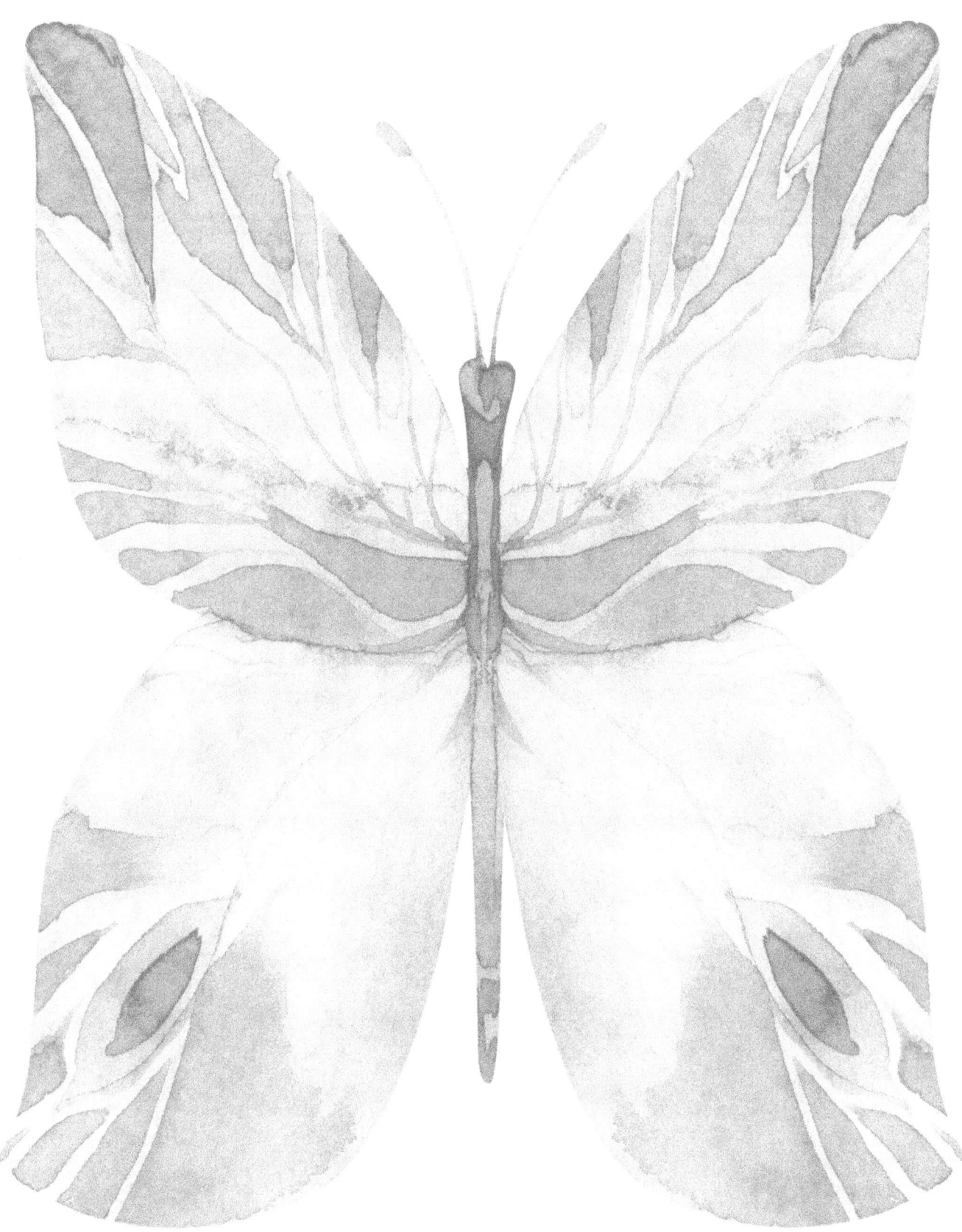

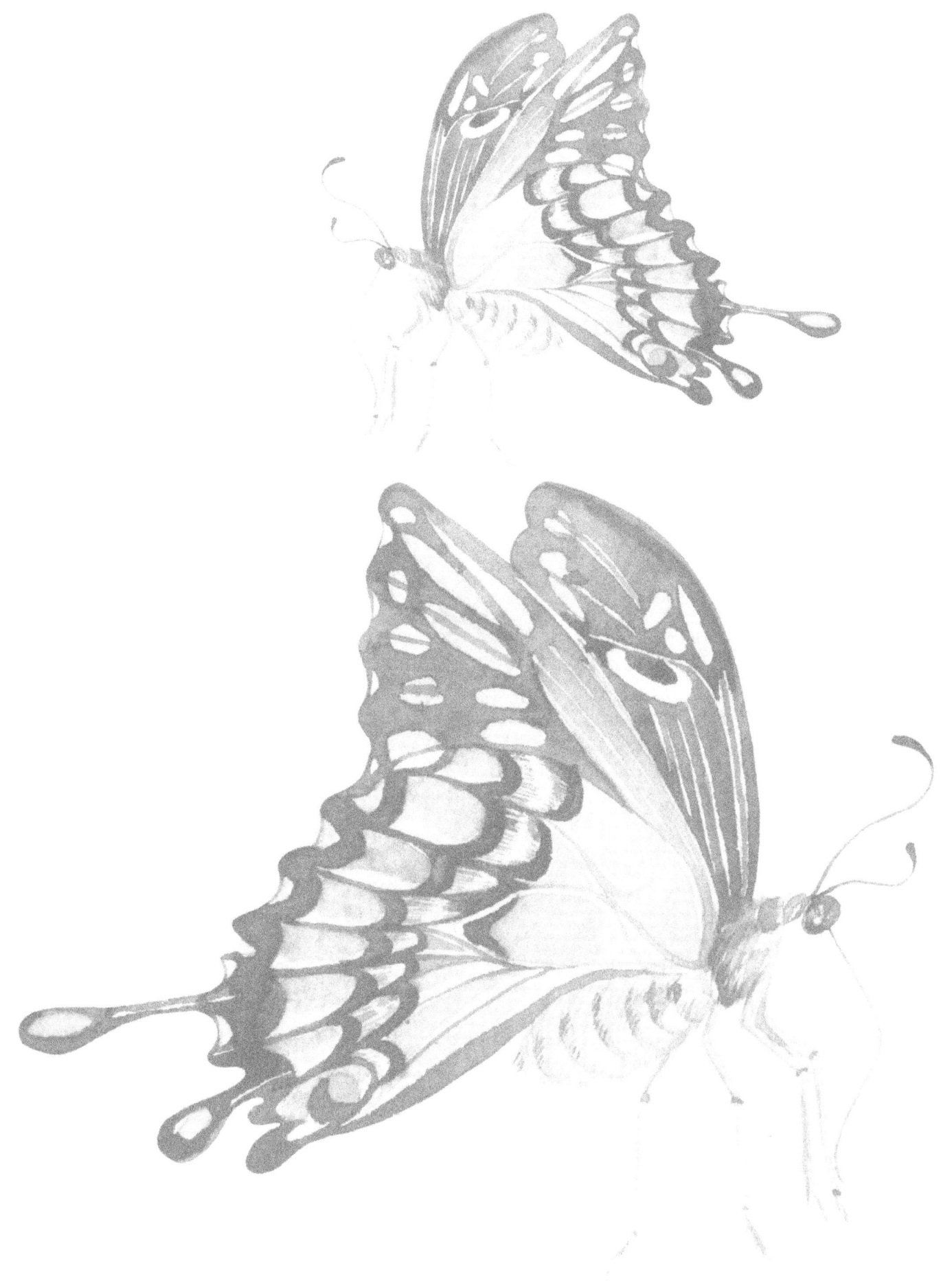

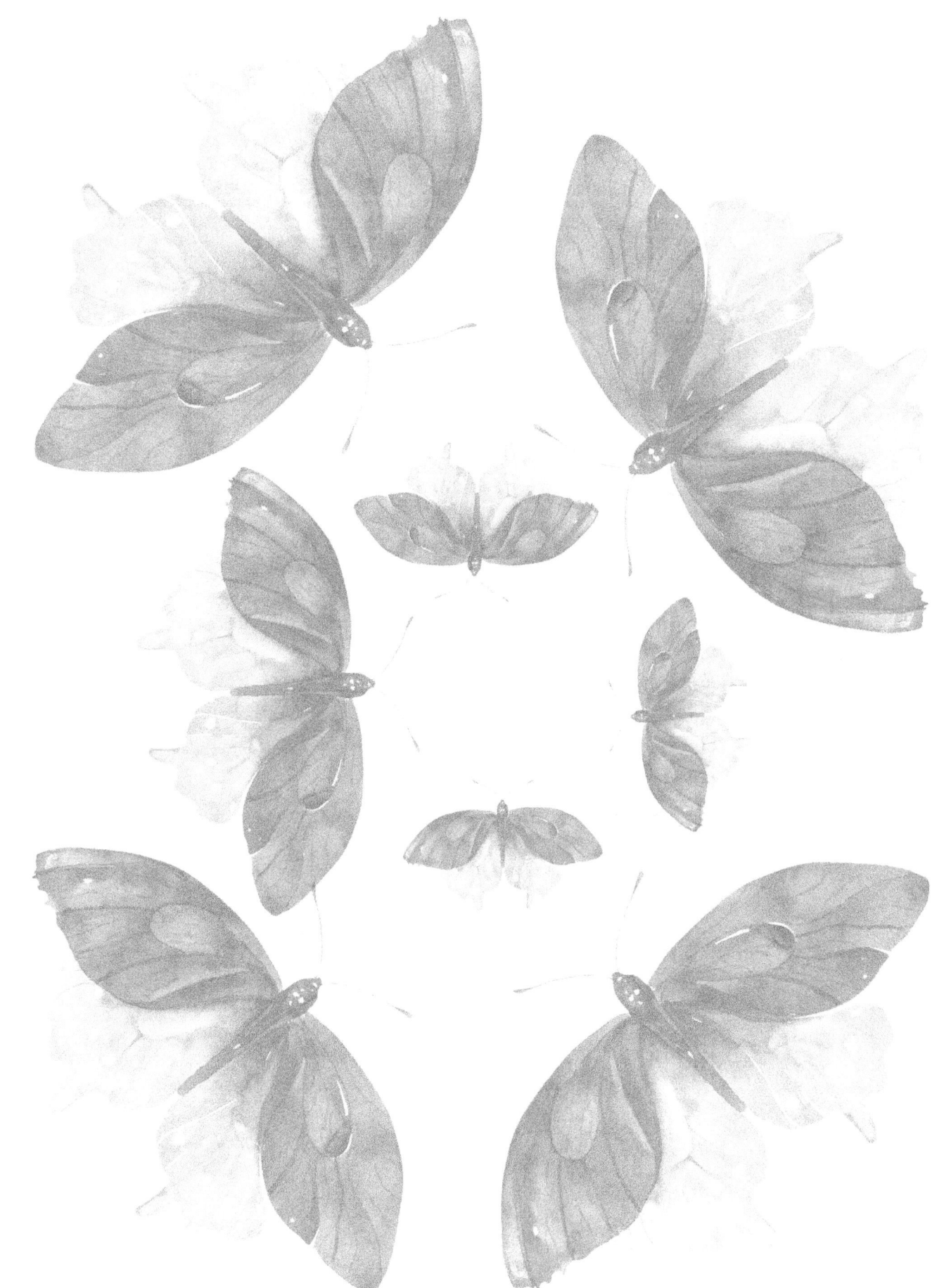

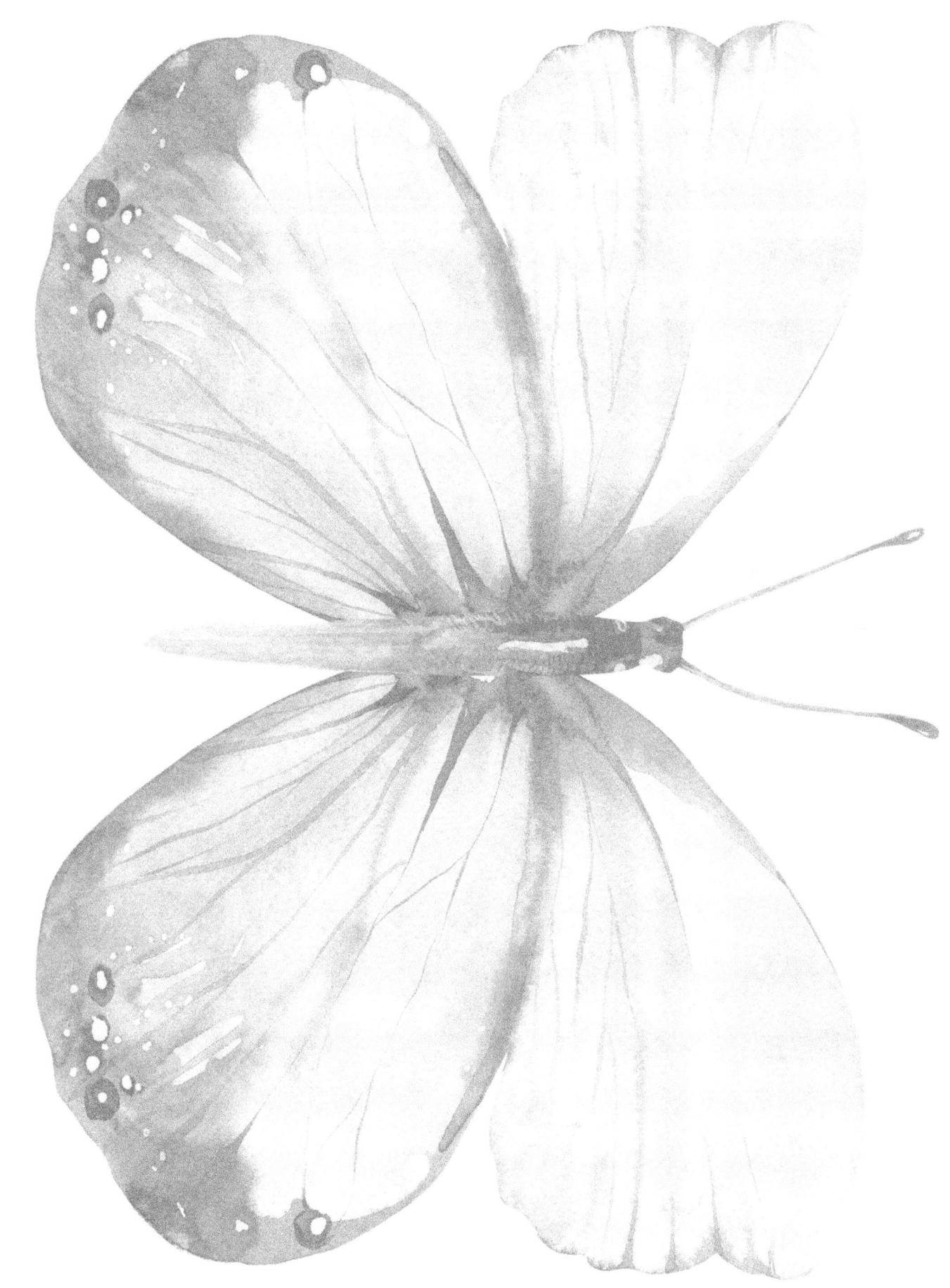

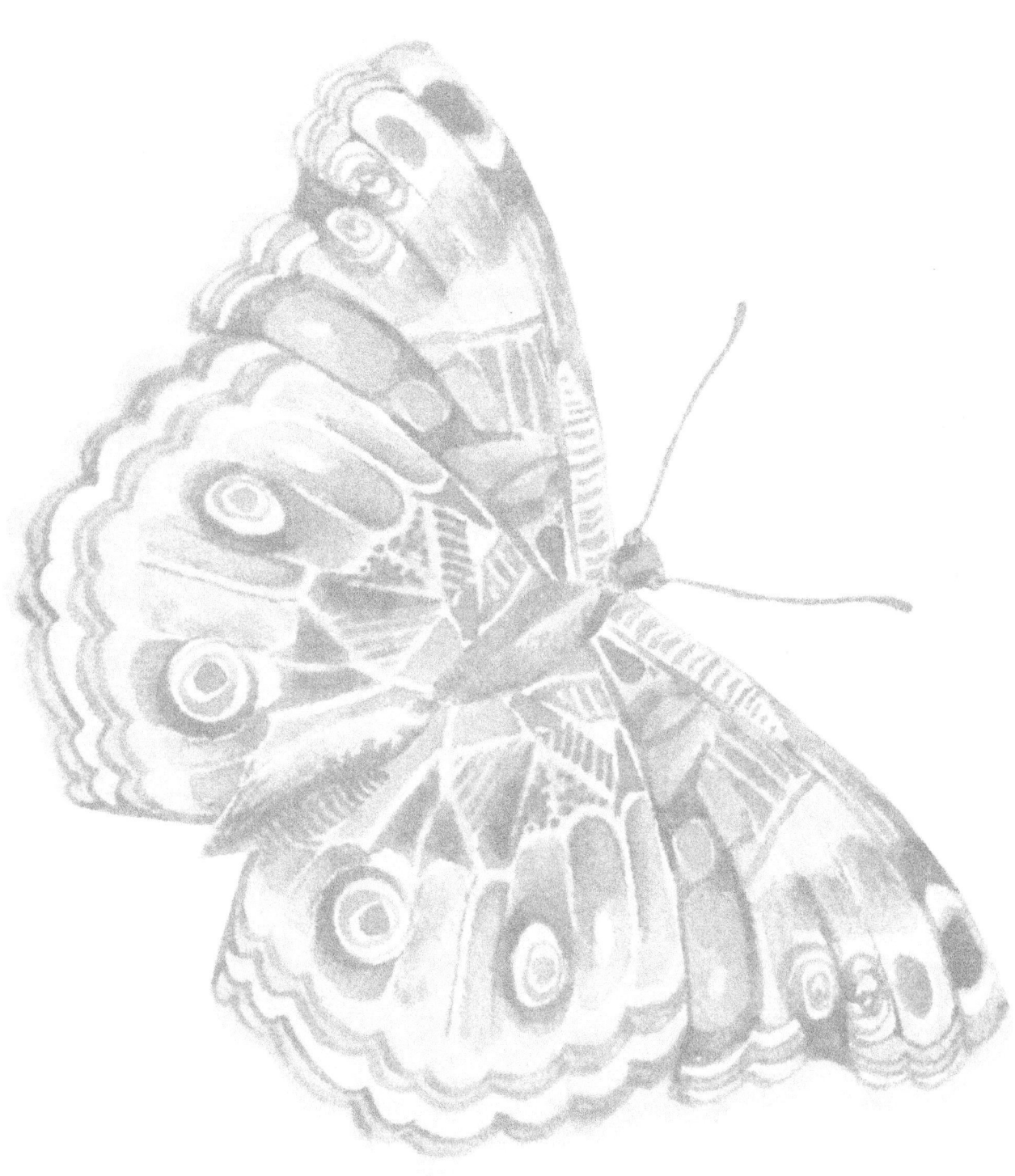

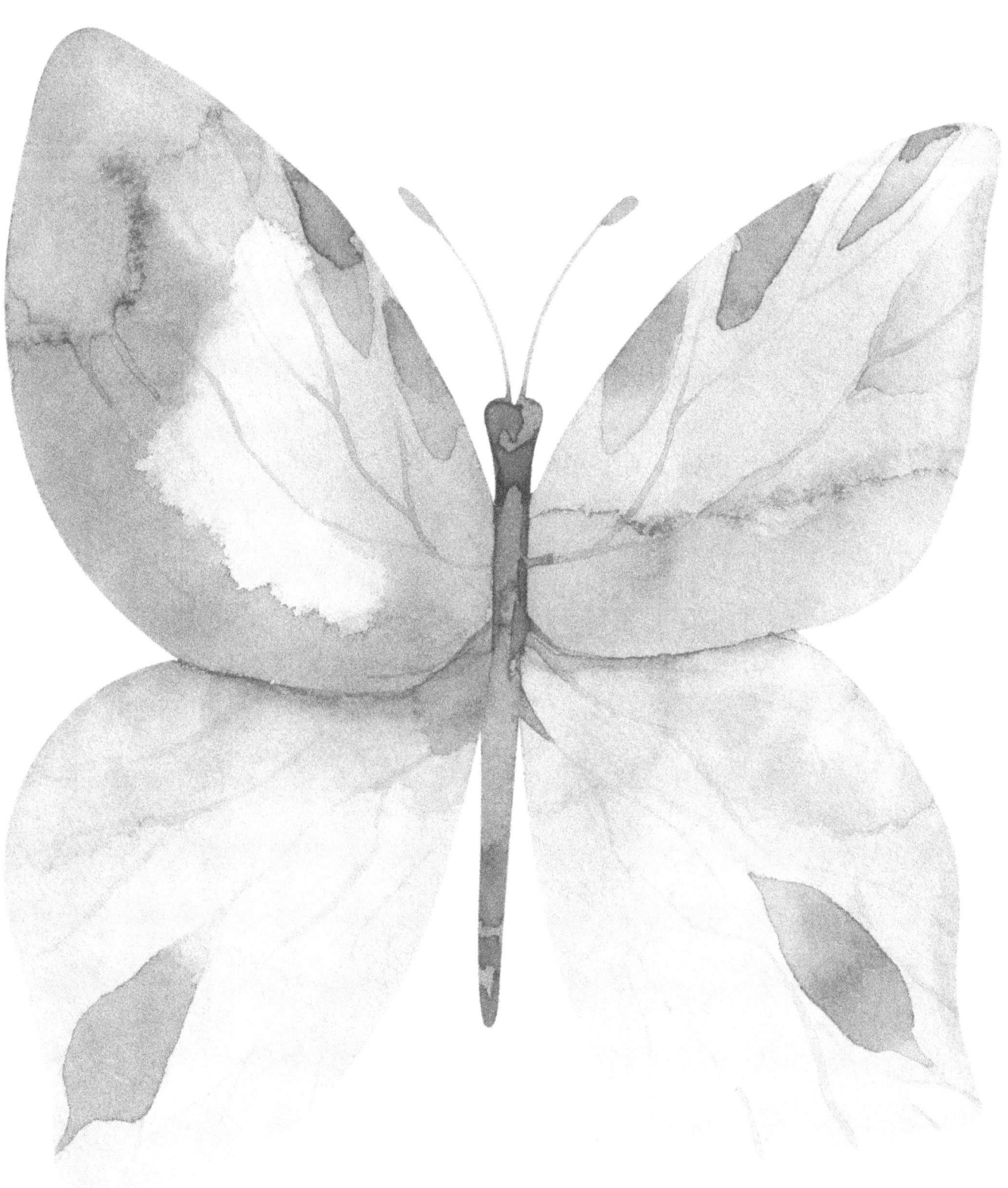

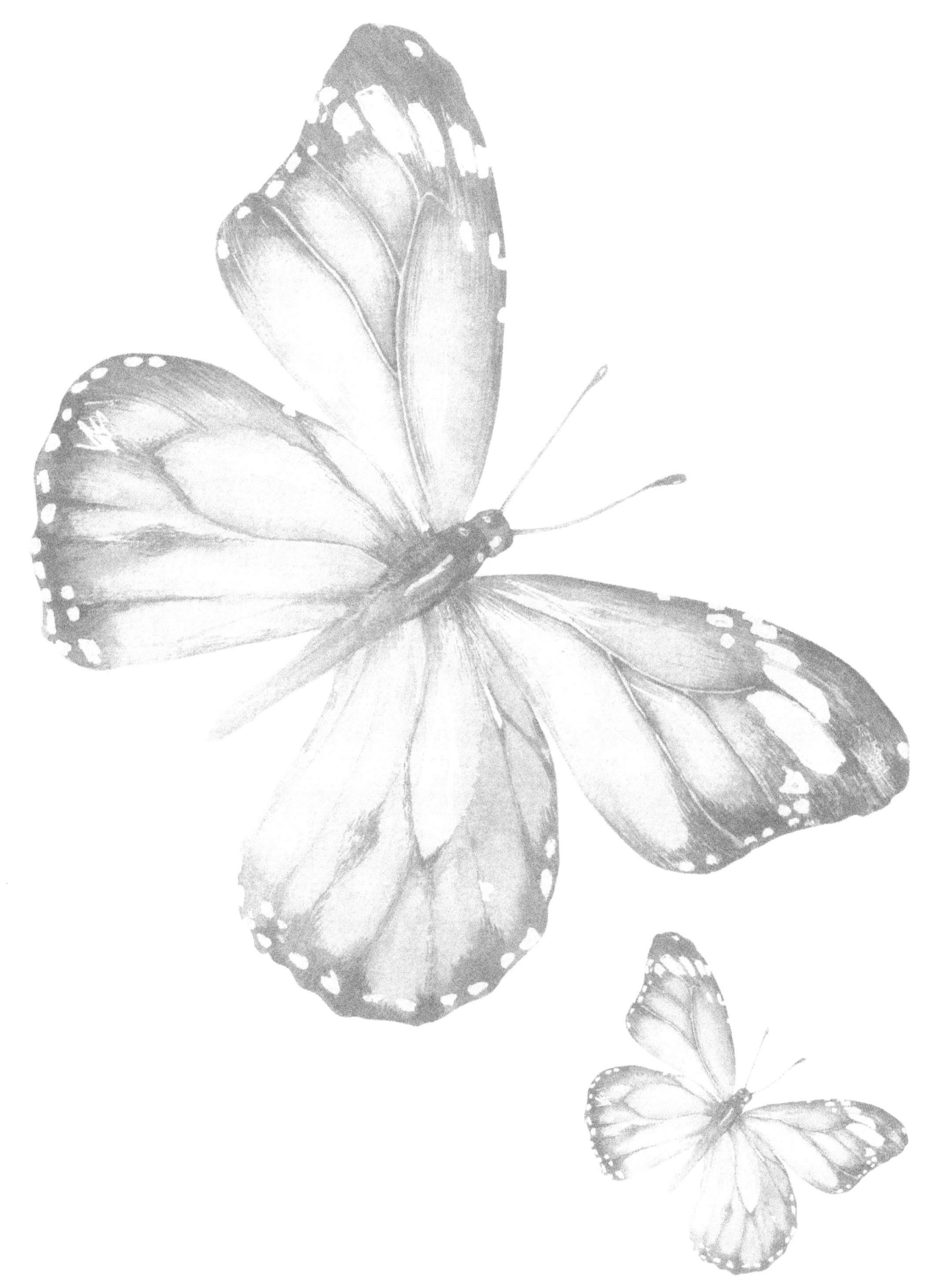

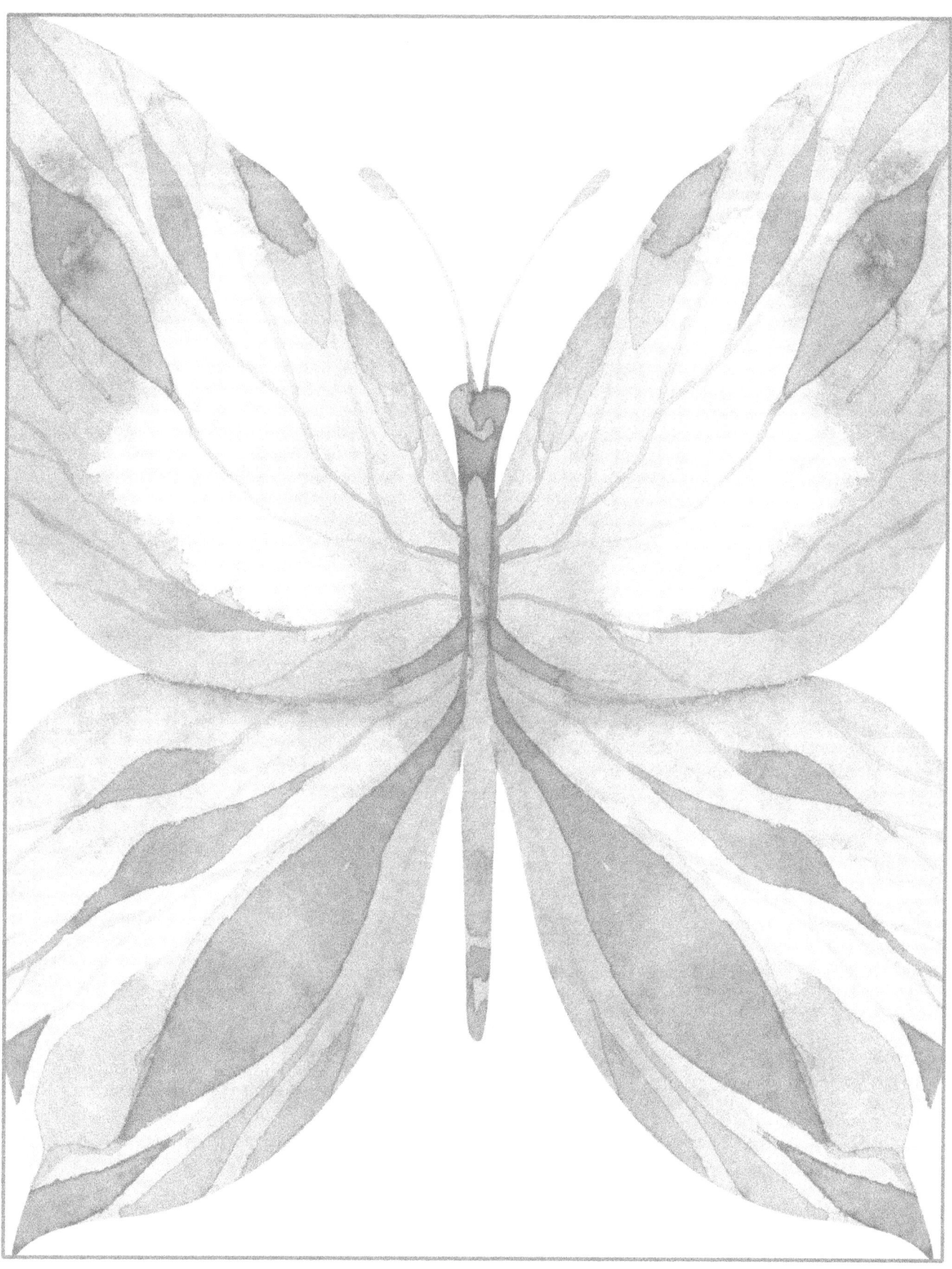

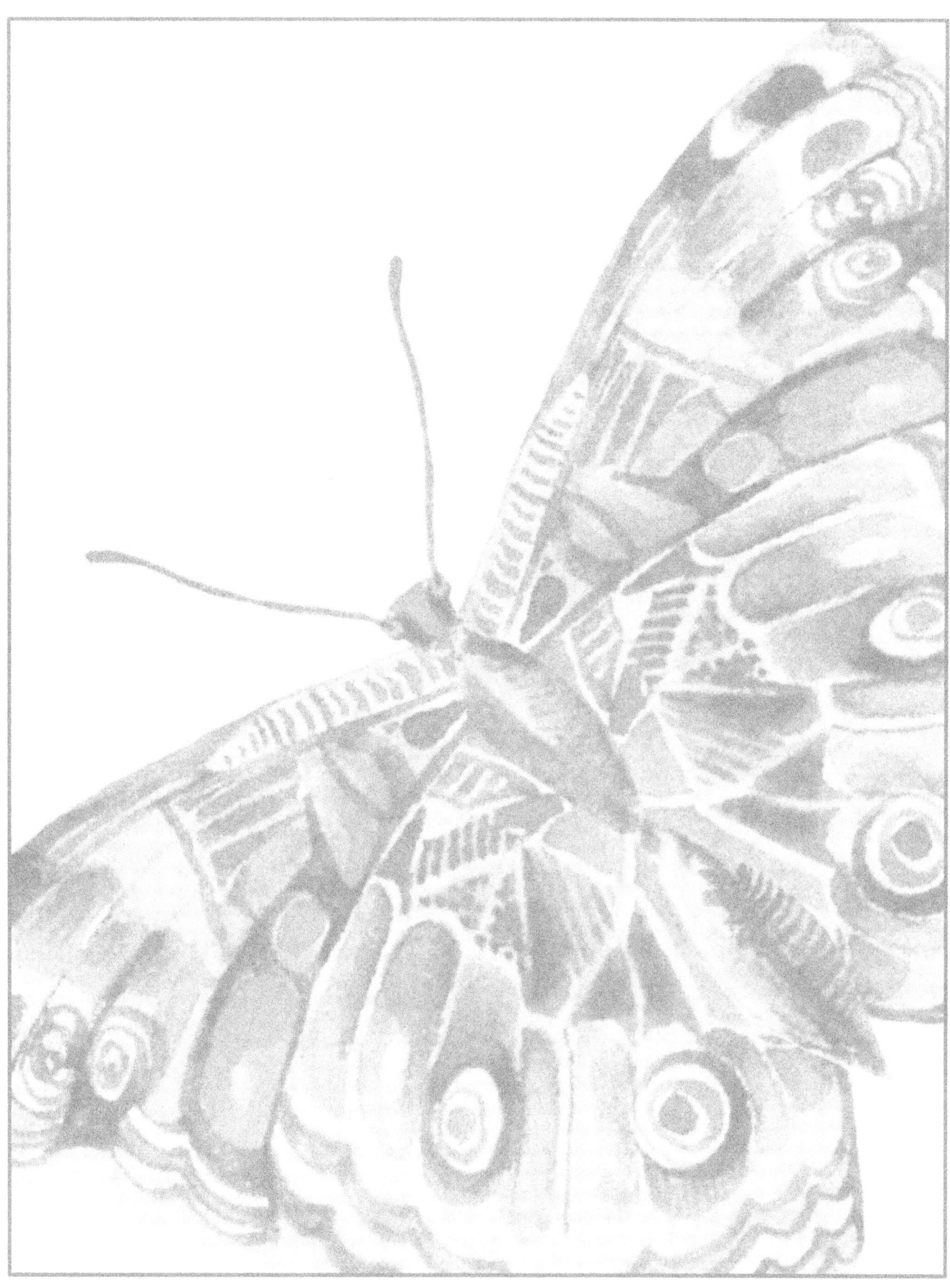

SweetTree Books/Colorist Café

Yay! You've finished this book!

If you'd like, go leave a review.

Don't forget some stars and a sentence or two!
Then have a look at some other books
We've created for you!

ColoristCafe.com/our-books